Chinese Calligraphy

Chinese Calligraphy

50 Characters to Inspire PEACE and CALM

Suvana Lin

Illustrations by A.D. Puchalski

—WELLFLEET—
PRESS

To Shannen: 但願人長久‧千里共嬋娟

Q Quarto Knows

Quarto is the authority on a wide range of topics.
Quarto educates, entertains and enriches the lives of
our readers—enthusiasts and lovers of hands-on living.
www.quartoknows.com

Text and calligraphy © 2016 Suvana Lin
Illustrations © 2016 Quarto Publishing Group USA Inc.

First published in the United States of America in 2016 by
Wellfleet Press, a member of
Quarto Publishing Group USA Inc.
142 West 36th Street, 4th Floor
New York, New York 10018
www.quartoknows.com

10 9 8 7 6 5 4 3 2 1

ISBN-13: 978-1-57715-130-2

Author and Calligrapher: Suvana Lin
Illustrator and Designer: A.D. Puchalski
Project Editor: S. M. Wu

Printed in China

CONTENTS

EMOTION

ENLIGHTENMENT

INTRODUCTION

The beauty of Chinese calligraphy, with its rich history and cultural influence, is that it is a living, constantly evolving writing system, which has withstood the test of time through its different styles and various poetic interpretations. As one of the oldest civilizations, China has more than 5,000 years of history. Its earliest form of written communication—oracle shell writing—dates as far back as the Shang dynasty (approximately 3,500 years ago). "Oracle shell writing" refers to carvings on tortoiseshell or animal bones. The Qin dynasty (about 2,200 years ago) unified the writing system with characters whose meanings are still used today.

For centuries, scholars have considered Chinese calligraphy a regimen, a practice of calming the mind and nurturing the heart. It is viewed not only as a way

to release stress and build patience but also as a path to self-development. It takes time and care to slowly grind the solid inkstone into liquid ink. Executing the brushstrokes also encourages good hand-eye coordination.

Chinese calligraphy has increased much in popularity nowadays, particularly among the younger generation. It has gained importance as a visual art form that is heavily influenced by culture and heritage. It is an art that most people can enjoy with minimal requirements—ink, brush, and paper.

My earliest memory of Chinese calligraphy is learning how to write my own name at the age of five. Writing Chinese calligraphy is something I enjoy doing. It is an art form that I came to appreciate and that has made me prouder of my Chinese heritage. Because I learned how to write using traditional characters (as opposed to the modern simplified characters), that is my personal preferred writing system. I have also included the Hanyu pinyin (romanized lettering of Chinese

ideograms) of each character so that it may be easily understood by anyone who is interested in learning the language.

The fifty characters that were chosen all evoke a sense of peacefulness. The book is separated into three sections, with each section emphasizing elements that may affect our state of mind: Nature, Emotion, and Enlightenment. Nature is all around us, greatly impacting our lives. A.D. Puchalski's lovely illustrations help to illuminate the fact that we can find nature in all things. The characters selected for the Emotion section highlight those emotions that, when cultivated, benefit our overall mental well-being. The characters in the Enlightenment section emphasize the relationship with oneself, and help us recognize how fortunate we are that we can acquire new skills and develop our infinite potential for personal growth.

In order to provide some background character information, I have broken down most characters into parts and tried to explain their origins. Each

character belongs under a particular Chinese radical (all characters contain at least one radical). A "radical" is similar to the root of a word and is mainly used for categorization in a dictionary. For example, if you wanted to find the character for "waterfall" (瀑—*pù*) in a Chinese dictionary, you would look under the radical for "water" (氵).

To assist with your calligraphy practice, a detailed representation of the strokes for each character has been included in an appendix (titled Character Strokes).

For ease of reference, the characters are listed alphabetically by their English translations within the appendix and their respective sections.

好運 (*Hǎo yùn*)—"Good luck!"

May your calligraphy be 龍飛鳳舞 (*lóng fēi fèng wǔ*)— "lively and free."

NATURE

Bird

niǎo

鳥

鳥 • Bird

Since ancient times, Chinese painters have portrayed birds in paintings as meaningful and significant images. The two most popular birds depicted in Chinese bird-and-flower paintings are the heron and the crane. The pronunciation of the Chinese character for heron, 鷺 (*lù*), has a sound like the Chinese character 路 (*lù*), which means "road" or "path." The crane (鶴—*hè*) is a symbol of longevity in Taoism.

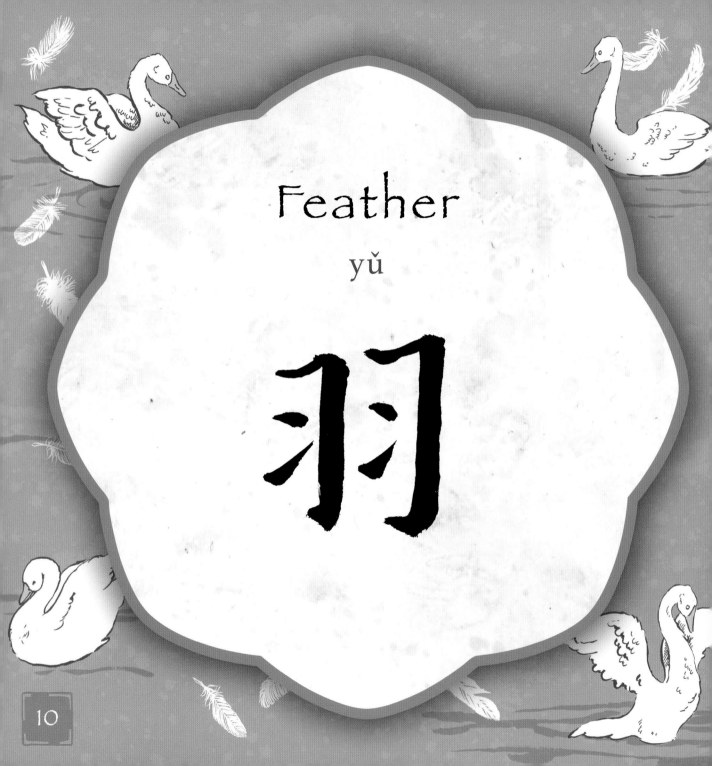

Feather

yǔ

羽

羽 • Feather

In oracle shell writing, the character for "feather" is a pictograph of the shape of two feathers. 羽 means the feathers from a bird or the wings from an insect. When combined with 毛 ("hair"), 羽毛 (*yǔ máo*) is the more common wording used to refer to the feather of a bird. According to one well-known Chinese allegorical saying, "Travel many miles to bestow a goose feather—a small gift may be a token of profound friendship."

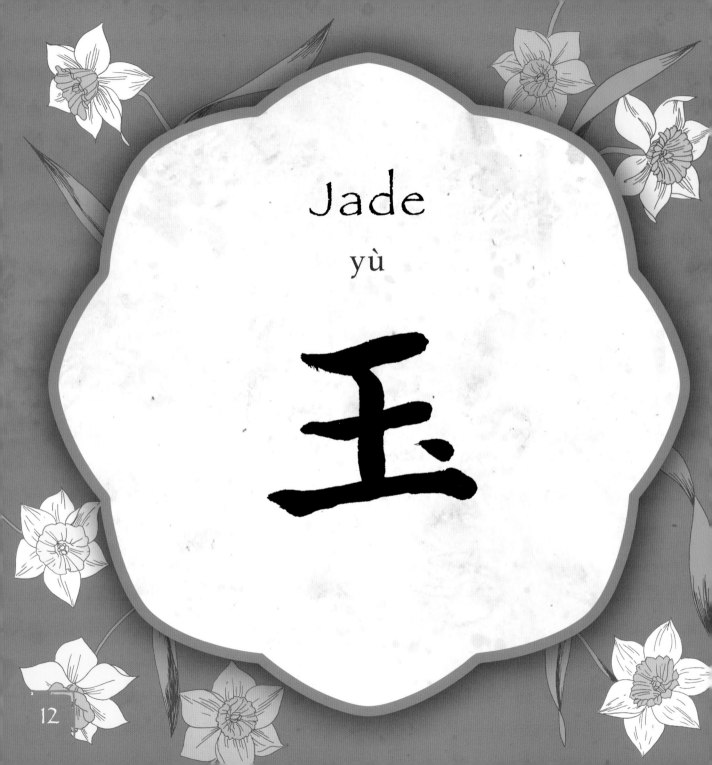

Jade

yù

玉

12

玉 · Jade

In oracle shell writing, the character for
"jade" looks like a string with three pieces
of circular jade stones linked together.
Jade is much loved and highly regarded by the
Chinese, as it is believed to calm the mind, ward
off evil spirits, and provide health benefits. It
is often used to symbolize purity, beauty, and
preciousness. As a Chinese proverb explains
it, "A speck on a jade stone won't obscure
its radiance."

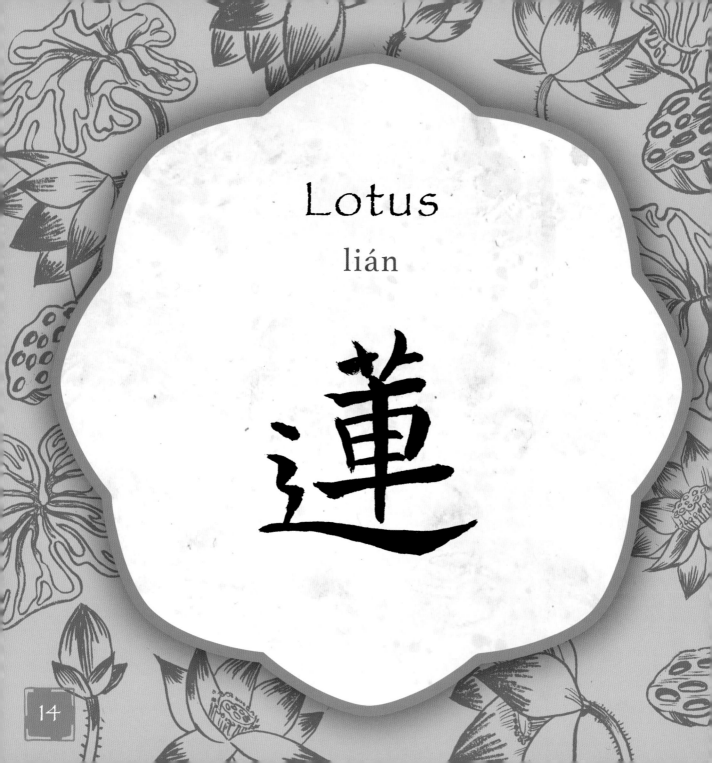

Lotus

lián

蓮

蓮 • Lotus

蓮 is a combination of three parts: 艹 (radical for "plant"), 車 ("carriage"; "cart"), and 辶 (radical for "movement"). The lotus is a longevity plant. Its seeds can germinate even after a thousand years. Besides being acclaimed for its reputed medicinal benefits, it is also highly regarded for its beauty. The lotus is a symbol of faith and the purity of the soul. As a renowned Confucian scholar wrote, "I love the lotus because, while growing from mud, it is unstained."

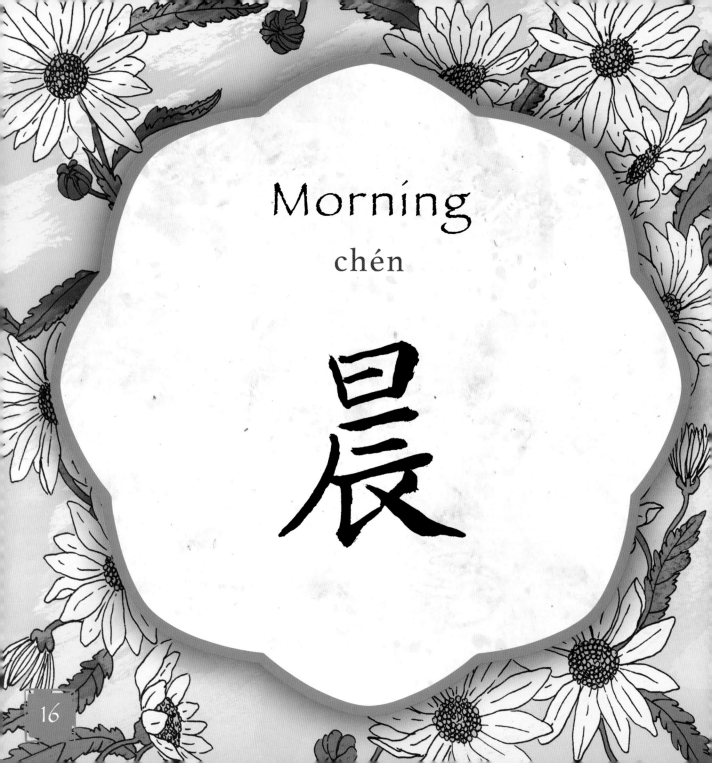

Morning

chén

晨

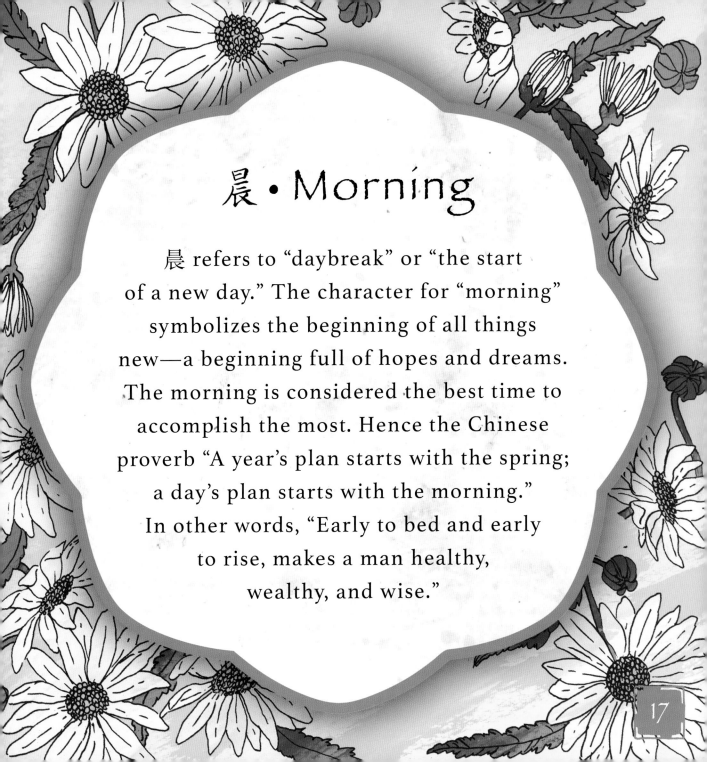

晨 · Morning

晨 refers to "daybreak" or "the start of a new day." The character for "morning" symbolizes the beginning of all things new—a beginning full of hopes and dreams. The morning is considered the best time to accomplish the most. Hence the Chinese proverb "A year's plan starts with the spring; a day's plan starts with the morning." In other words, "Early to bed and early to rise, makes a man healthy, wealthy, and wise."

Orange

chéng

橙

橙 • Orange

橙 also means the color orange. The left side of the character for "orange" is derived from 木 ("tree"). The right side is a combination of two parts: 癶 (radical for "legs") and 豆 (radical for "peas" or "beans"). 橙 is a round citrus fruit with reddish-yellow skin that is grown in tropical and subtropical areas. In Chinese culture, oranges and tangerines are often used and given during Chinese New Year to symbolize abundance, good fortune, and happiness.

Pearl

zhū

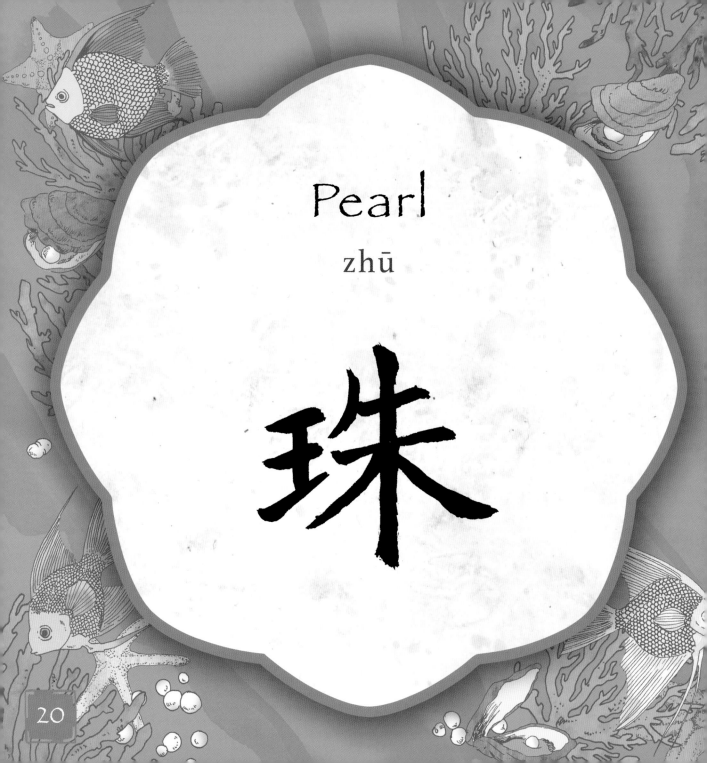

珠 • Pearl

The left side, 王 (radical for "jade"), means a translucent, lustrous surface. The right side is 朱 ("ball-like object"). 珠 is used to describe a pearl that is produced by an oyster. Pearls are usually strung together and are considered very precious in Chinese culture. The phrase 珠聯璧合 (*zhū lián bì hé*) means "a string of pearls and jade." It refers to the ideal combination of good events or talented people. The phrase is often used as a toast to celebrate a perfect marriage or union.

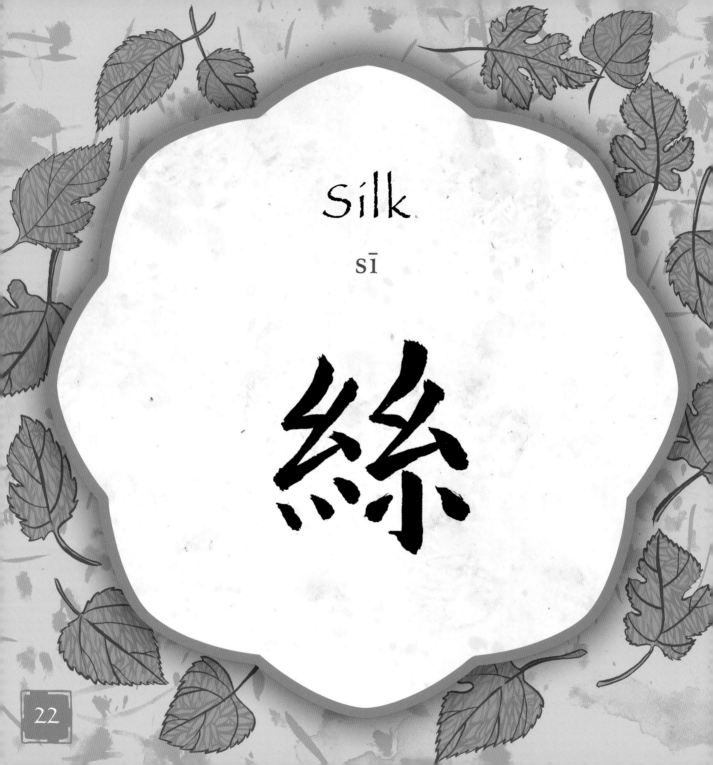

Silk

sī

絲

絲 • Silk

In oracle shell writing, the character for "silk" looks like two knotted silk cords. 絲 can also refer to "fine threads" or "string." Most often, 絲 refers to fabrics made of silk, a natural material shaped like fine threads that is secreted by silkworms to create a cocoon covering. Silk was first developed in China to create luxury items for the emperor. In the words of a Chinese proverb: "With time and patience, the mulberry leaf becomes a silk gown."

Sunlight

yáng

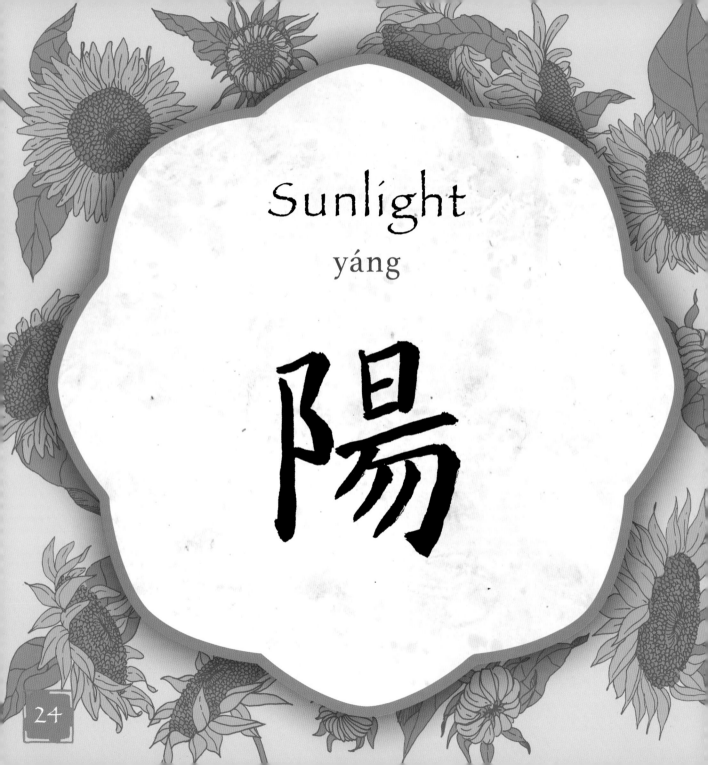

陽 • Sunlight

When combined with 太 ("great"), the phrase 太陽 (*tài yáng*) means "the sun." The Chinese proverb 三陽開泰 (*Sān yáng kāi tài*) is an auspicious traditional phrase that is often used to celebrate Chinese New Year. It means "The beginning of spring, the beginning of luck." The character 陽 has the same sound as 羊 ("sheep"), which is considered a lucky animal in Chinese culture.

Time

shí

時 • Time

In ancient Chinese writing, the character for "time" consists of two parts: the top part, 业 ("advance"; "progress"; "sprout"), and the bottom part, 日 (radical for "sun"). The original meaning referenced the daily movement of the sun and the changing of the seasons. To quote a famous Chinese proverb regarding the value of time: "An inch of time is an inch of gold, but an inch of time cannot be purchased with an inch of gold."

Waterfall

pù

瀑

瀑 • Waterfall

瀑 consists of two parts: 氵 (radical for "water") and 暴 ("sudden bursts of energy"). In *shan shui* (山水—"mountain water") paintings, waterfalls are often depicted as a wondrous body of water flowing down from steep mountains, forming a dreamlike majestic view. *Shan shui* paintings are traditional Chinese landscape paintings that are strongly influenced by Taoist philosophy. Taoist teaching emphasizes the importance of human beings living in harmony with nature.

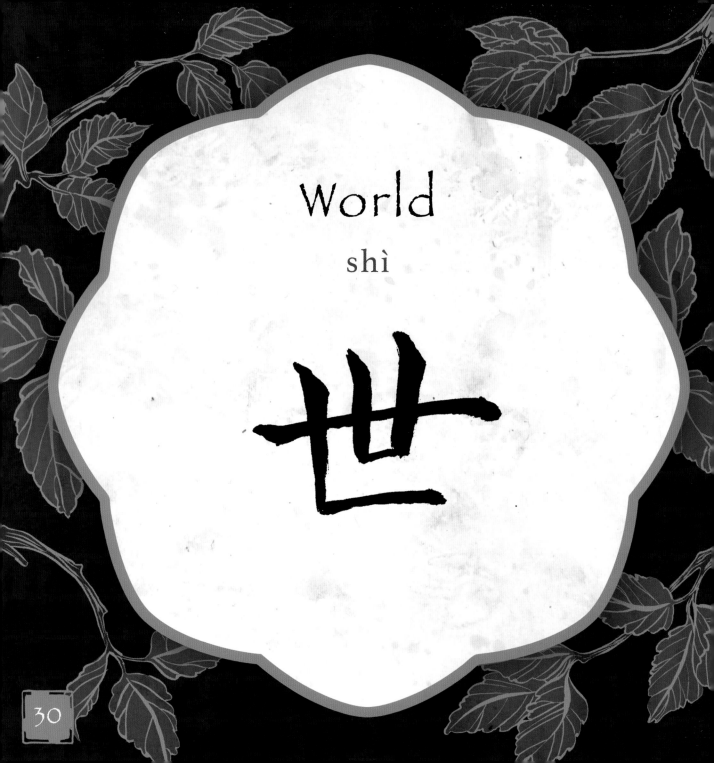

World

shì

世

世 • World

In oracle shell writing, the character for "world" is a pictograph of three leaves on a branch—with each leaf representing one decade. In ancient China, thirty years represented a generation. 一世 means "one lifetime." In Buddhism, the phrase 一花一世界，一葉一菩提 (*Yī huā yī shì jiè, Yī yè yī pú tí*) means "One flower, one world, one leaf, one buddhi." In other words, if we open up our minds, each individual flower, leaf, or person is unique in its own way. Enlightenment can be found everywhere.

EMOTION

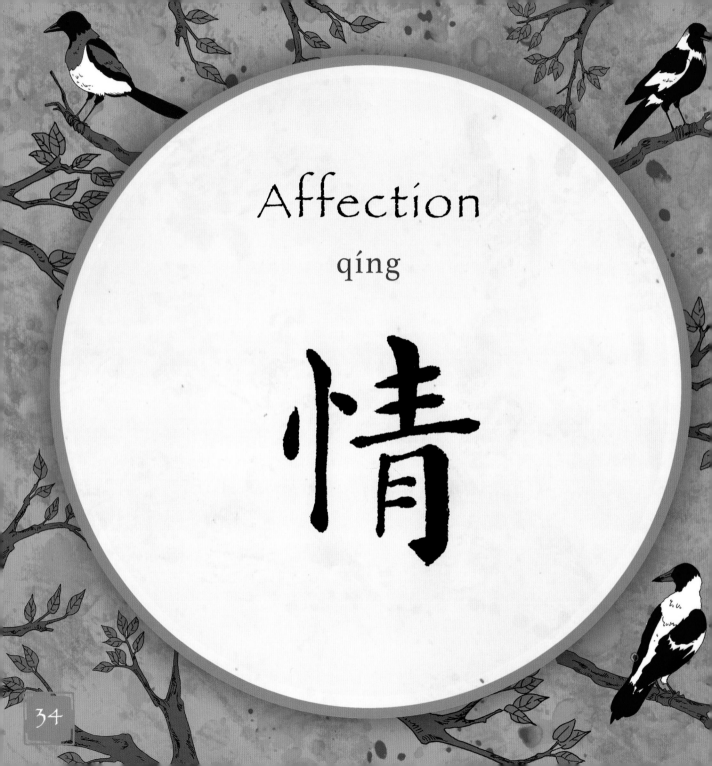

Affection

qíng

情

情 · Affection

情 means feelings or sentiments coming from the heart. When combined with other characters, it distinguishes different types of love or affection. For example, 愛情 (*ài qíng*) means passionate love between two persons, 友情 (*yǒu qíng*) means "friendship," and 親情 (*qīn qíng*) means "kinship." The Chinese phrase for "Valentine's Day" is 情人節 (*qíng rén jié*), which means "festival celebrating people who are dear to us."

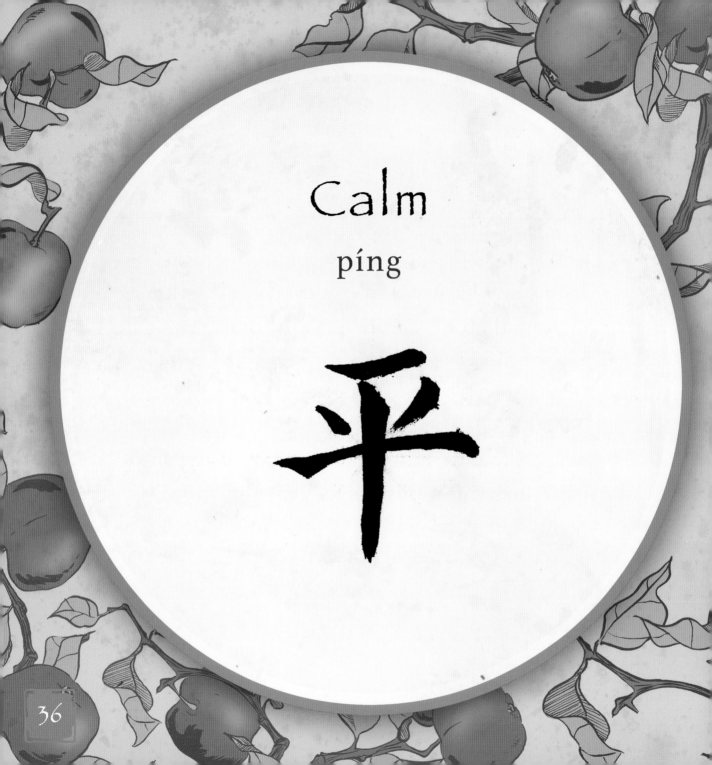

Calm

píng

平

平 • Calm

The character for "calm" consists
of two components: 干 ("a shield") and
ˇ (radical for "separation"). 平 can also
mean "even." 平 signifies the leveling of any
unevenness and creation of a flat surface. In
China, 平 is a popular name, as it represents the
parents' hope that their child lead a smooth
life facing few obstacles. In the words of
a Chinese proverb: "The life of the
virtuous may be expected to glide
calmly on and long."

Contentment

măn

滿

滿 • Contentment

The character for "contentment" literally means "to reach the limit" or "fullness." 滿 is an auspicious decorative character used as a blessing for abundance and prosperity. The Chinese saying 心滿意足 (*Xīn mǎn yì zú*—"Heart, contented; idea, ample") reflects the happy feeling of being perfectly and completely satisfied after performing a task or receiving a payment or a gift that is favored.

Dream

mèng

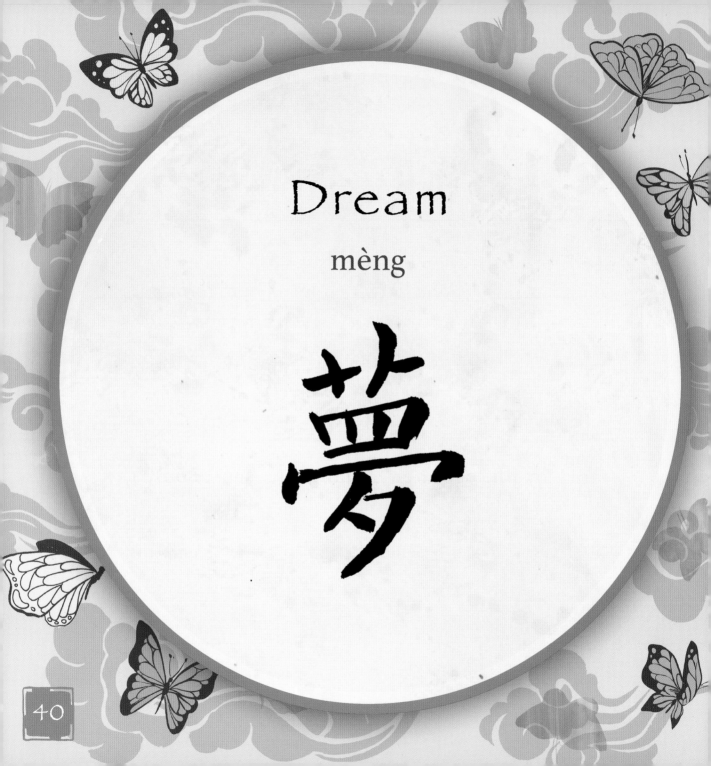

夢 • Dream

In oracle shell writing, the character for "dream" is a pictograph of a person asleep on a bed, but with a fluttering eye movement, which might indicate that he or she is dreaming. When combined with 想 ("think"; "want"), the phrase 夢想 (*mèng xiǎng*) means "dreaming of a goal" or "having an expectation for the future." The best-known story by philosopher Zhuangzi (c. 369–286 BC) is "Butterfly Dream." In his dream, he is turned into a butterfly, happy and carefree, without a thought for everyday troubles.

Forgive

liàng

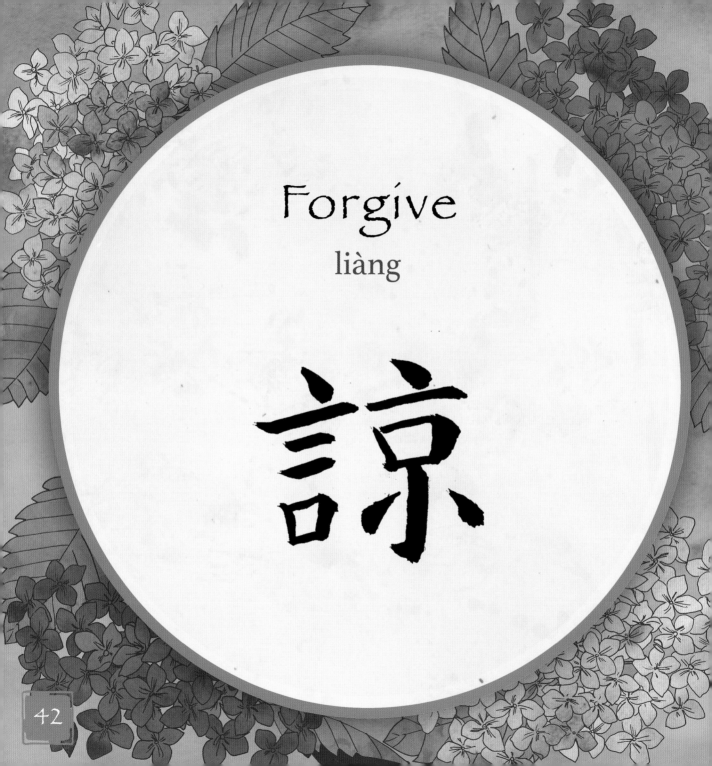

諒 • Forgive

諒 has two components: 言 ("speaking words") and 京 ("watchtower"). In Chinese culture, speaking honestly and truthfully is a highly regarded characteristic and considered noble. When combined with 原 ("the cause"; "source"), 原諒 (*yuán liàng*) means understanding the causes of the faults and mistakes of others and being willing to dissolve conflicts with no harsh judgment. One should have compassion and forgive others as one would forgive oneself.

Gentle

róu

柔

柔 • Gentle

柔 consists of two parts: the top part, 矛, is the character for "spear," and the bottom part, 木, is the character for "wood." 柔 is used to describe something as soft, gentle, and flexible. It is the opposite of 剛 (*gāng*), meaning "hard" and "strong." 柔能制剛 (*Róu néng zhì gāng*) is a Chinese saying that means "Gentleness can overcome might." Sometimes being gentle and diplomatic can resolve a conflict more efficiently than aggression.

Good

hǎo

好

46

好 • Good

In ancient Chinese writing, the
character for "good" is a pictograph of a
woman holding her child. It means that with
a new birth comes good fortune and happiness.
When combined with 美 ("beautiful"), the phrase
美好 (*měi hǎo*) means "wonderful" and "full of
wellness." A common reply to the question
你好嗎? (*Nǐ hǎo ma?*)—"How are you?" or
literally "Are you well?"—is 我很好
(*Wǒ hěn hǎo*): "I am well."

Happiness

xǐ

喜

喜 • Happiness

The character for "happiness" is composed of two parts: the top part, 壴 ("a drumlike musical instrument"), and the bottom part, 口 ("mouth"). It represents the jubilant laughter that occurs during happy moments. The character 囍 (*xǐ*) — which means "double happiness" in English — is commonly used as an ornament character for moments of celebration such as a wedding. A popular greeting during Chinese New Year is 恭喜發財 (*Gōng xǐ fā cái*), which means "Wishing you happiness and prosperity."

Heart

xīn

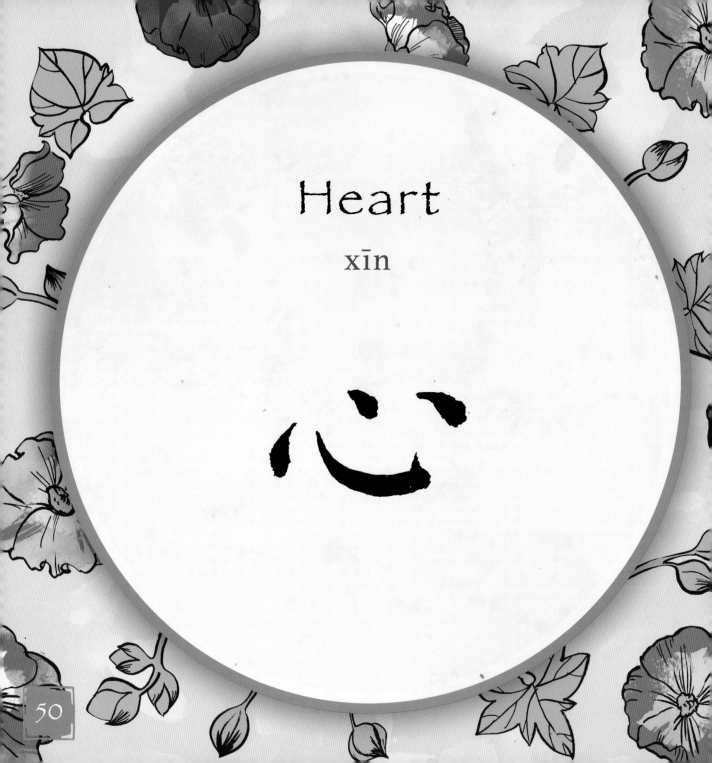

心 • Heart

心 is used as a component in many
Chinese characters that describe feelings
or intentions, including, for example, 恕
("forgiveness"), 愛 ("love"), and 慧 ("intelligent").
The Chinese saying 心平氣和 (*Xīn píng qì hé*)
means "Heart, calm; breath, peace." The saying
reminds us to always maintain a calm and
peaceful manner and to not feel angry or
impatient when facing unexpected or
unpleasant events.

Home

jiā

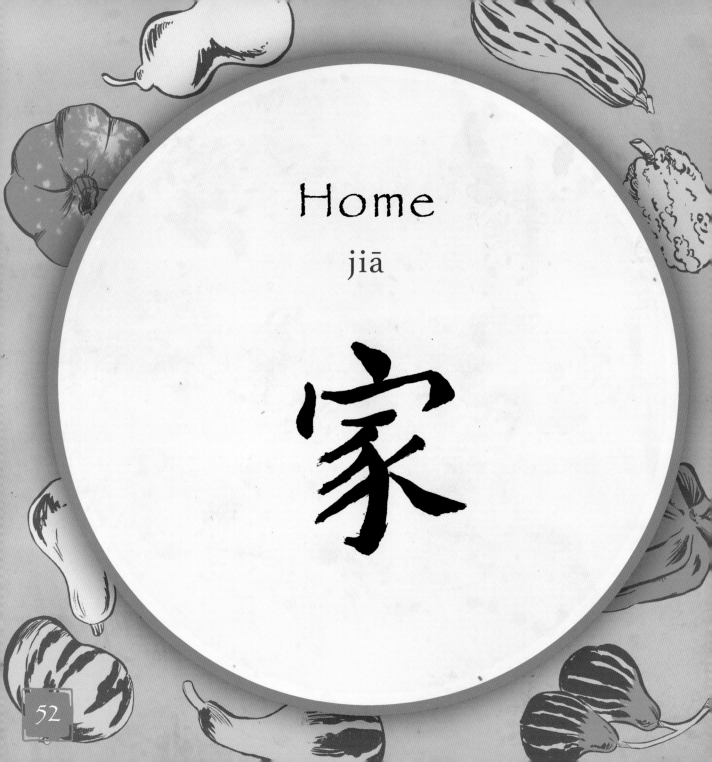

家 • Home

家 is composed of two parts: the top part, 宀, is from the radical for "roof," and the bottom part, 豕, is from the radical for "pig." In ancient China, most people were farmers who raised livestock in or near their living quarters. A pig ensured a food supply and provided security for the family. 家 also means "family." To quote a Chinese saying: 家和萬事興 (*Jiā hé wàn shì xīng*)—"A harmonious family brings happiness."

Hope

wàng

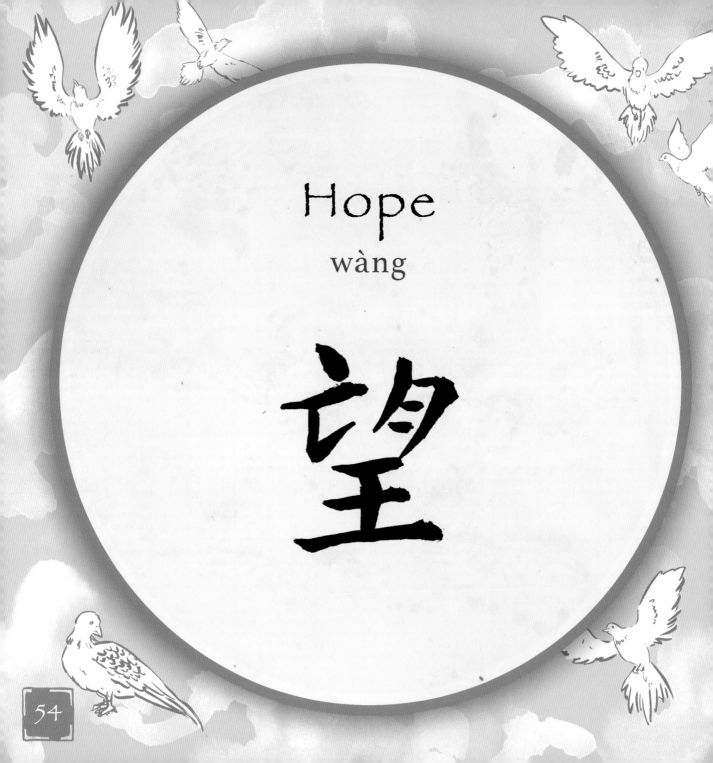

望 · Hope

望 means to look far ahead with hope and expectation. In oracle shell writing, the character for "hope" is a pictograph of a person standing on the ground, gazing into the distance. 望 is often combined with the character 希 ("rare"). The phrase 希望 (*xī wàng*) means "wishing for one's hopes to come true." According to a famous Chinese proverb: "Where there is life, there is hope." The proverb means that through difficult times and struggles, one must not give up hope and surrender to despair.

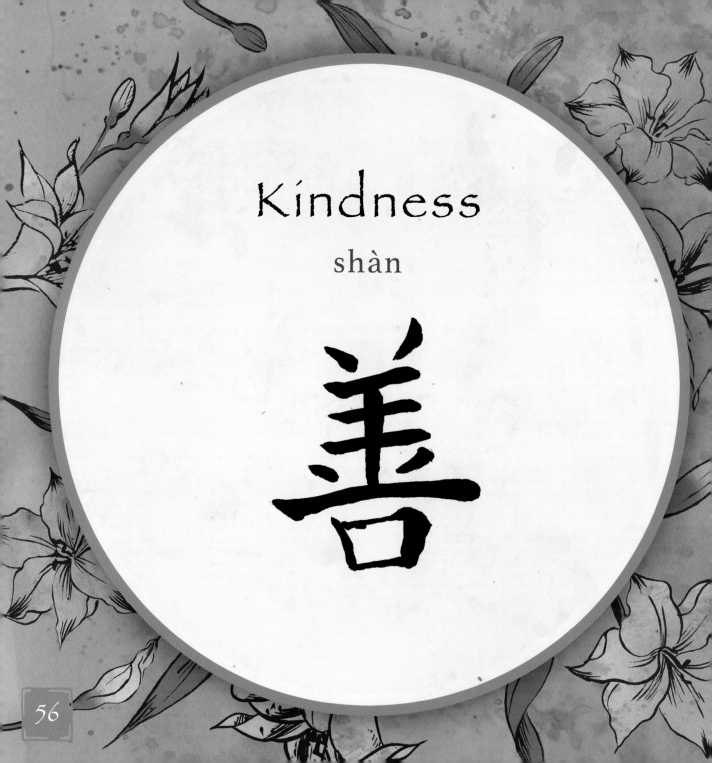

Kindness

shàn

善

善 • Kindness

In oracle shell writing, the character for "kindness" is a pictograph of the head of a sheep with slanted eyes. 善 means "with virtuous and kind behavior." Sheep symbolize good luck in Chinese culture. 善 has an auspicious meaning, but it also means "skillful," "perfect," and "charitable." When combined with 心 ("heart"), 善心 (*shàn xīn*) means "benevolence." Benevolence is the core concept of moral ethics for Confucianism's teaching of virtue.

Laughter

xiào

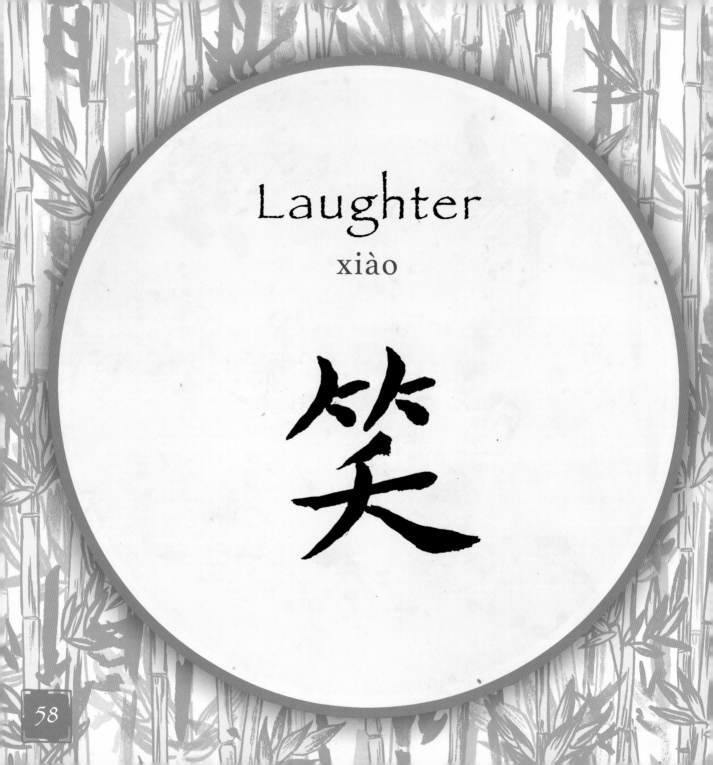

笑 • Laughter

笑 consists of two parts: the top part, 竹, is from the radical for "bamboo," and the bottom part, 天, resembles a person dancing. In ancient China, they believed that the laughter of a person was similar to the sound of wind blowing and bamboo leaves whistling. According to a well-known Chinese proverb: "Just one laugh makes the person ten years younger." In other words, keeping a happy and optimistic view of life can help with maintaining a healthy body.

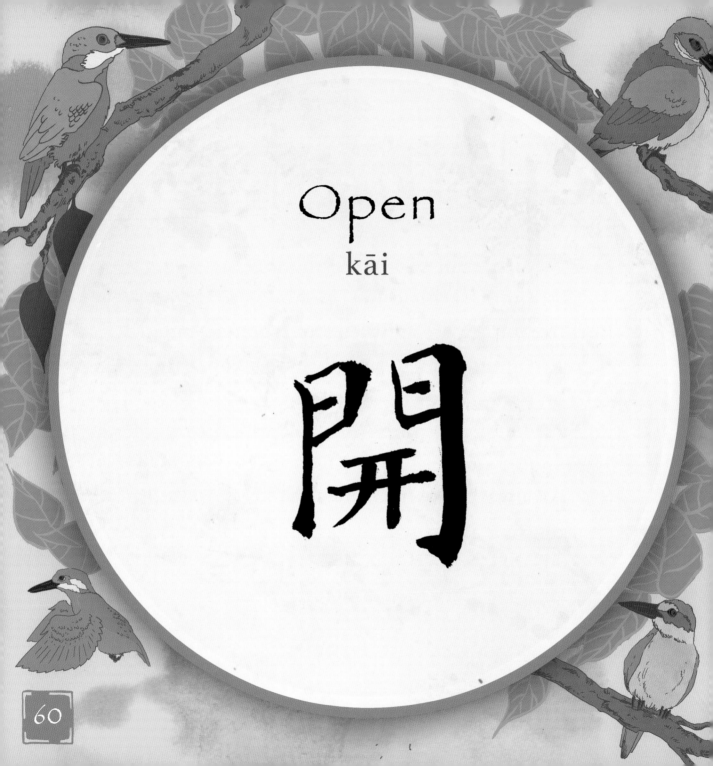

Open

kāi

閑

開 · Open

開 has two components: 門 ("door") and
开 ("a pair of hands"). 開 means to use both
hands to push open a door, but it also means
to feel happy. The phrase 開心 (*kāi xīn*) literally
means "open heart." 開朗豁達 (*kāi lǎng huò dá*)
means keeping a positive and optimistic attitude
and handling matters with an open mind.
As a well-known Chinese proverb says:
"A closed mind is like a closed book;
just a block of wood."

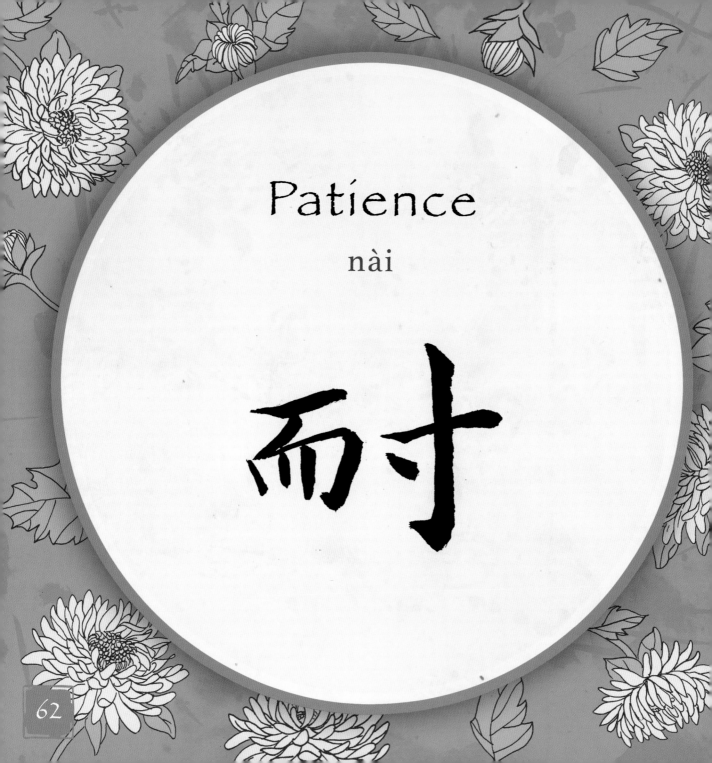

Patience

nài

耐

耐 • Patience

耐 originally referred to a minor form of punishment in which a man's beard was removed. In ancient China, the cutting of one's hair or the shaving of one's beard was viewed as an act of dishonor or shame that one must endure. 耐 eventually evolved to mean "endurance" or "patience." To quote Chinese philosopher Lao-tzu: "I have just three things to teach: simplicity, patience, compassion. These three are your greatest treasures."

Peace

hé

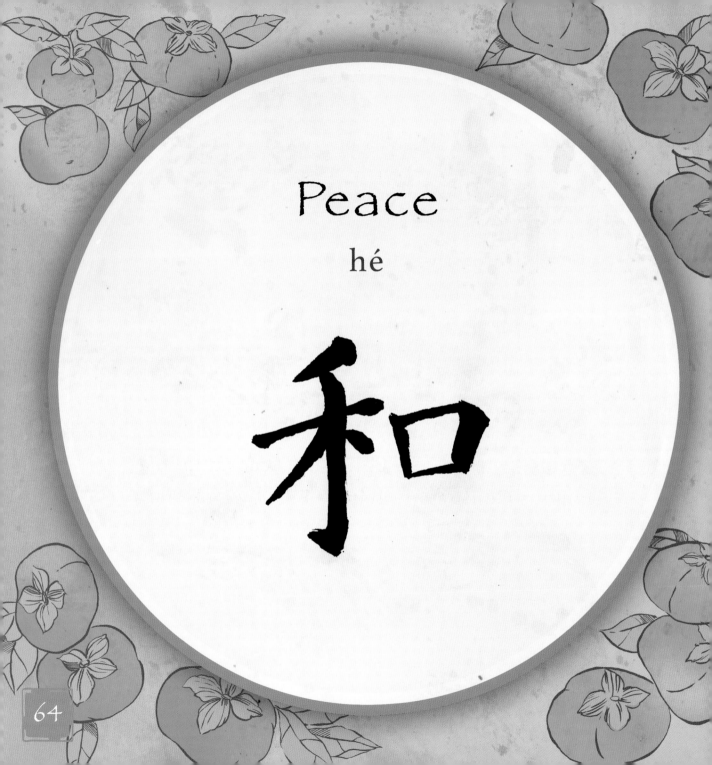

和 • Peace

和 is a combination of two characters:
禾 ("grain"; "rice plant") and 口 ("mouth").
和 also means "harmony." 以和為貴 (*Yǐ hé wéi guì*) means "Harmony is a highly regarded value." It is a Confucian philosophy that notes the importance of reaching harmony from different ideas and opinions. According to a famous Confucian saying, "Education breeds confidence. Confidence breeds hope. Hope breeds peace."

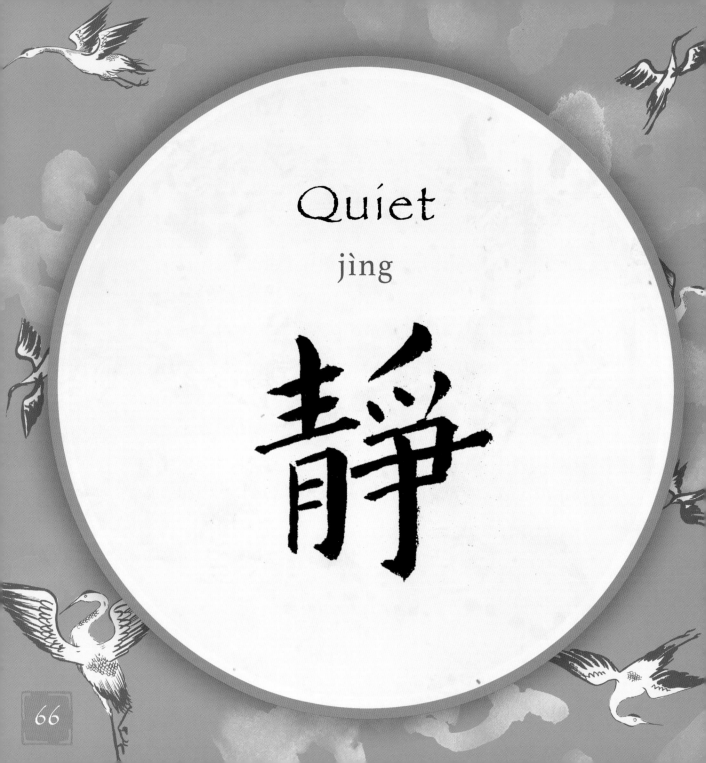

Quiet

jìng

靜 • Quiet

靜 is a combination of two characters:
青 ("cyan"—the color of the sky on a bright,
sunny day) and 爭 ("dispute"; "fight between"). A
poetic translation of 靜 is "Let go of the fight and
look at the blue sky." The character reminds us
to quiet our busy minds and calm our hearts.
To quote a famous Chinese proverb: 静以修身
(*Jìng yǐ xiū shēn*), which means "Quiet thoughts
mend the body." In other words, improve
and better yourself with serious
self-reflection.

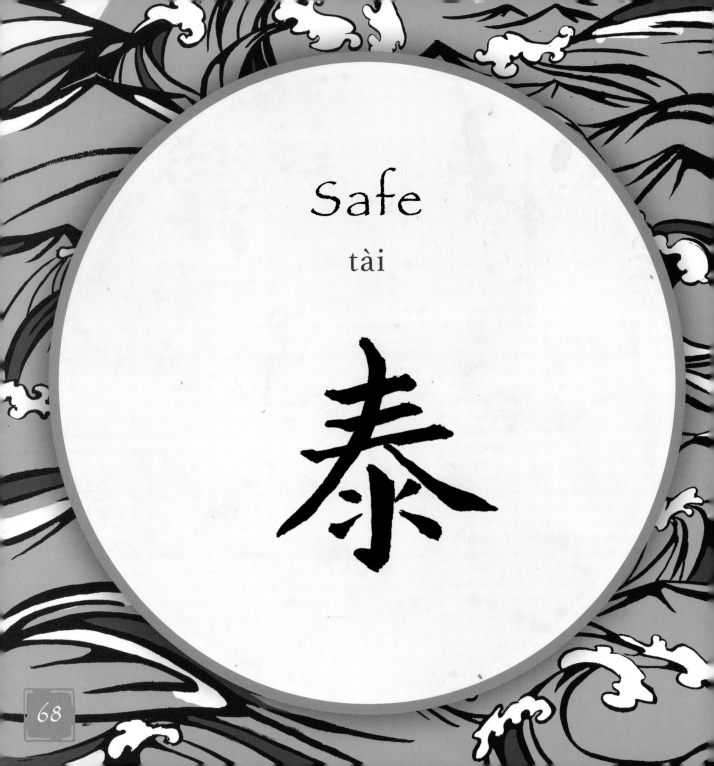

Safe

tài

泰

泰 • Safe

泰 is a combination of two parts: 夫 (resembling folded hands) and 氺 (radical for "water"), which means a person using both hands to cleanse himself or herself with water. In Chinese culture, it is believed that cleansing one's body of dirt will bring good luck and health. The character signifies escaping from danger to safety. The Chinese phrase 泰然處之 (*tài rán chǔ zhī*) means to maintain a calm and composed attitude when facing unexpected and difficult situations.

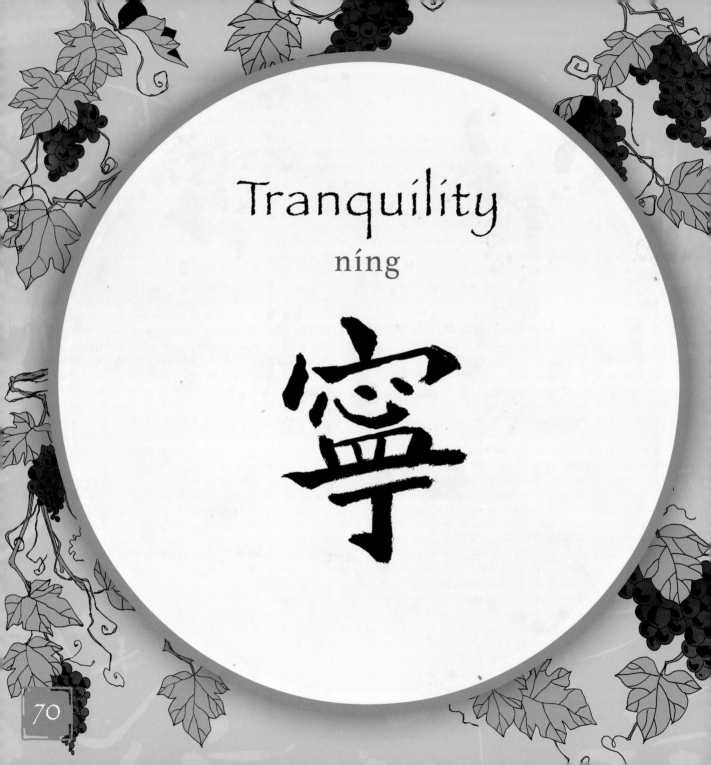

Tranquility

níng

宁

寧 · Tranquility

寧 consists of four parts: the top, 宀, is from
the radical for "roof"; the two middle parts
are the characters for "heart," 心, and "vessel,"
皿; and the bottom part, 丁, is the character for
"person." The quietness and stillness of the image
of a vase being placed safely in a house evokes
a calm serenity and feeling of safety in the
heart. 寧 can also mean "peace." 福壽康寧
(*Fú shòu kāng níng*) is a popular phrase for
celebration. It means "Happiness,
longevity, health, and peace."

ENLIGHTENMENT

Blessing

fú

福

福 • Blessing

福 consists of two parts: 礻 (radical for "to show") and 畐 ("to fill"—which resembles a well-fed person). Within 畐 is the character 十 (the number ten), which means "perfection." 福 also means "luck" and "happiness." 福 is an auspicious decorative character and is traditionally hung upside down to indicate that good luck or a blessing of good fortune is arriving. In Chinese, the word for "upside down"—倒 (*dào*)—has the same sound as the word for "arrives"—到 (*dào*).

Center

zhōng

中 • Center

The character for "center" is shaped like a flag centered on a pole. It is used to describe the "middle," "half," or "center." 中國 (*Zhōng guó*—"China") literally means "the Middle Kingdom." 中庸 (*Zhōng yōng*—"Doctrine of the Mean") is a principle of Confucianism. 中庸 advocates moderation in one's life and keeping an impartial attitude toward any situation. It is the belief in following nature and allowing it to take its course.

Destiny

yùn

運 · Destiny

運 consists of three parts: 車 ("carriage"; "cart"), 冖 (radical for "a cover"), and 辶 (radical for "movement"). 運 conveys a meaning of transport or the movement involved in an orbit. When combined with 命 ("life"), the phrase 命運 (*mìng yùn*) means a series of events that will affect a person's life, or, in other words, one's luck or fate. In the words of a Chinese proverb: "Watch your actions; they become habit. Watch your habits; they become character. Watch your character; it becomes your destiny."

Empowered

néng

能 • Empowered

In oracle shell writing, the character for "empowered" is a pictograph of a bear, which has a strong mouth and powerful feet. 能 is used to describe the ability to accomplish goals and tasks, and having a can-do attitude. A Chinese saying emphasizing this positive, goal-oriented mind-set is 無所不能 (*Wú suǒ bù néng*), which means "There is nothing that cannot be achieved or realized." In other words, a capable person can accomplish anything.

Eternal

héng

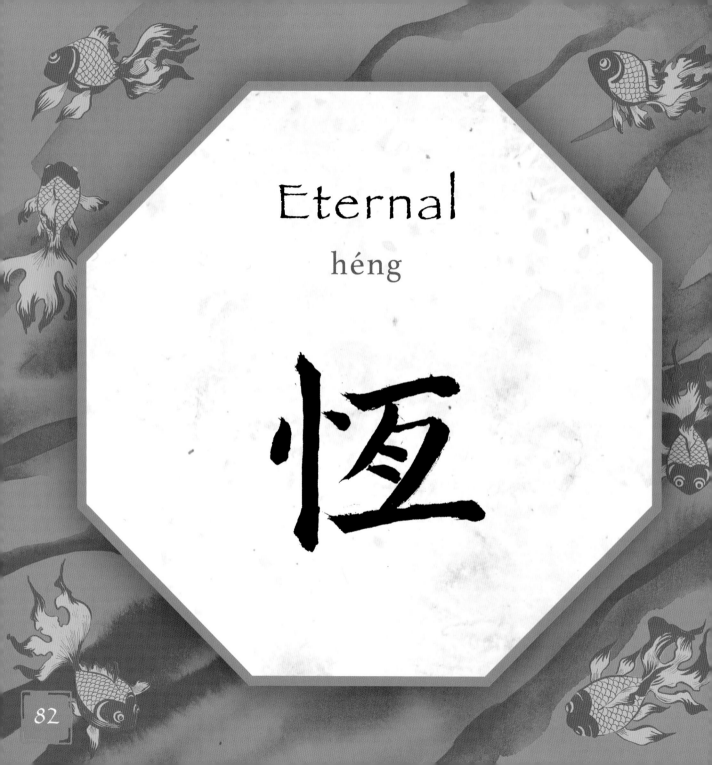

恆 · Eternal

In oracle shell writing, the character for "eternal" has three components: the top and bottom line represent "heaven" and "earth," and the third component is the character for "moon." It represents the waxing and waning of the moon or the passing of time. When combined with 永 ("forever"), the phrase 永恆 (*yǒng héng*) means "everlasting and constant." To quote a Chinese saying: "The reason why the universe is eternal is that it does not live for itself; it gives life to others as it transforms."

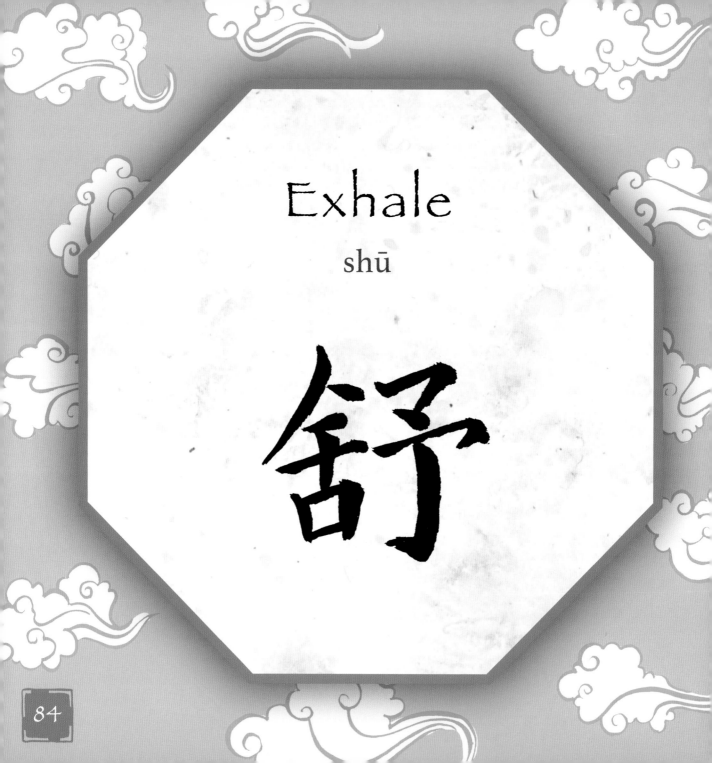

Exhale

shū

舒

舒 · Exhale

舒 is composed of two characters: 舍 ("release") on the left side, and 予 ("given") on the right side. It signifies stretching and slowness. When 舒 is combined with the character 適 ("suitable"; "appropriate"), the phrase 舒適 (*shū shì*) means "comfortable." 舒 can also mean "relax." The Chinese phrase 舒心如意 (*shū xīn rú yì*) is used to describe feeling pleased and happy because everything is proceeding smoothly and according to one's heartfelt wishes.

Exist

cún

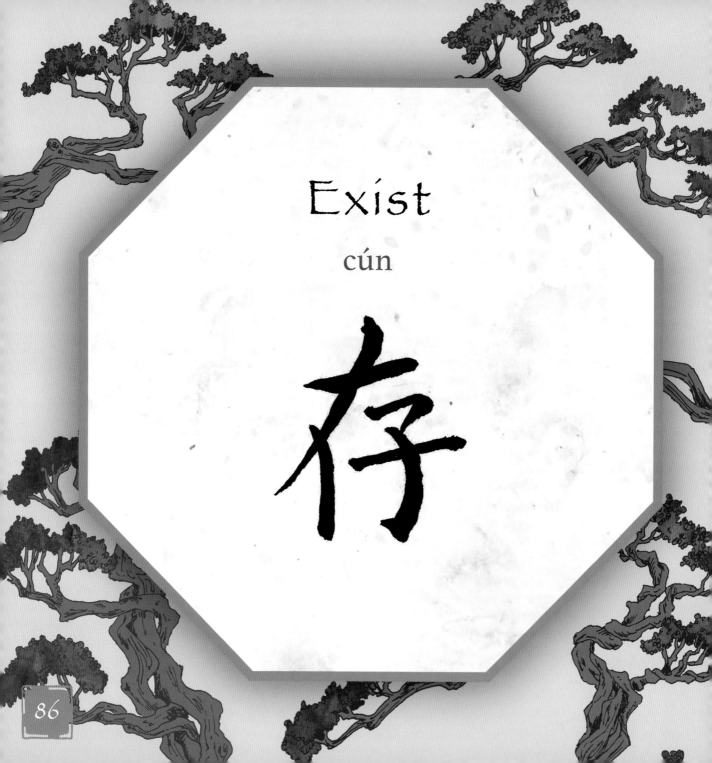

存・Exist

In oracle shell writing, the character for "exist" is a pictograph of a combination of young trees and children. 存 signifies a utopia where man and nature can coexist peacefully. Since ancient times, nature has been the one to protect and shelter mankind. Compassion and gratitude toward nature will bring peace to the earth. When paired with the character 在 ("present"; "to be"), the phrase 存在 (*cún zài*) represents existence, a proof of living in this world.

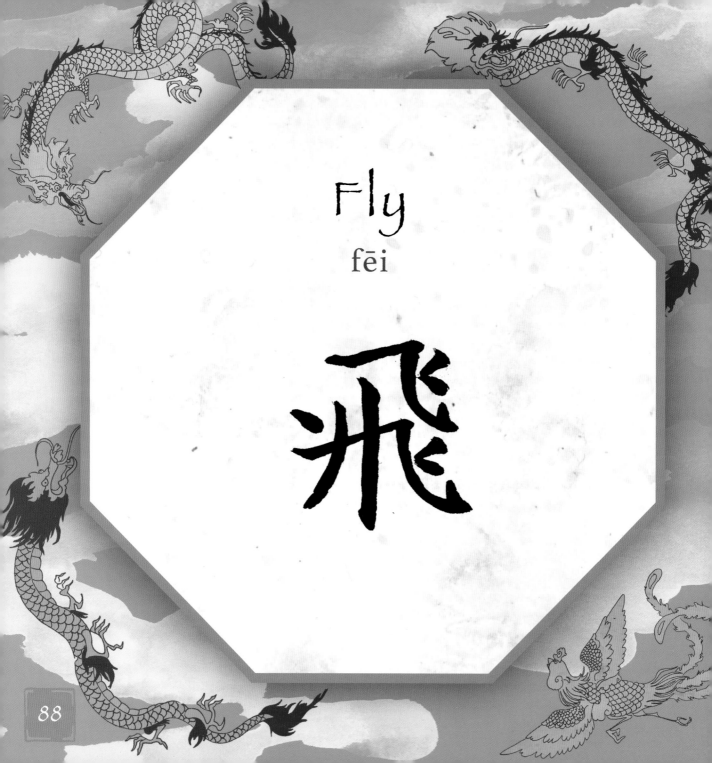

Fly

fēi

飛 • Fly

In oracle shell writing, the character
for "fly" is a pictograph that looks like
a bird soaring in the sky. 飛 means "to fly,"
but it can also mean "going quickly." When
combined with the character 舞 ("dance"), 飛舞
(*fēi wǔ*) means "dancing in the air." The Chinese
saying 龍飛鳳舞 (*lóng fēi fèng wǔ*) means "flying
dragons and dancing phoenixes"—a traditional
auspicious Chinese art pattern. The phrase
is also used to describe calligraphy
writing as "lively and free."

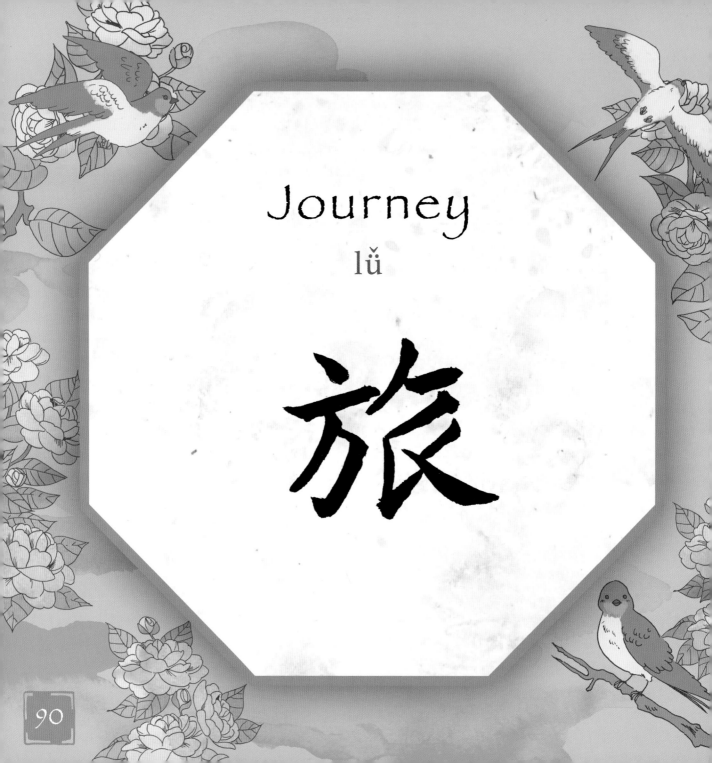

Journey

lǔ

旅

旅 • Journey

In oracle shell writing, the character for "journey" is a pictograph of a flag with people standing underneath it. The character originally referred to when soldiers would hold the flag while patrolling or traveling. 旅 also means "travels" and "visits." When combined with 行 ("walking"), the phrase 旅行 (*lǚ xíng*) means leaving for a faraway journey. To quote Lao-tzu: "A journey of a thousand miles begins with one step."

Knowledge

zhī

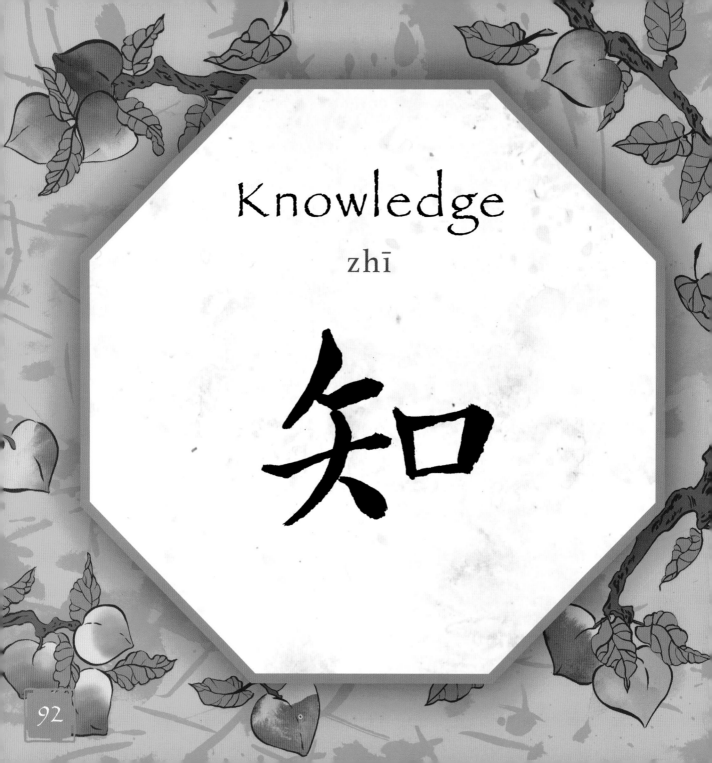

知 • Knowledge

The character for "knowledge" consists of two parts: 矢 ("arrow") and 口 ("mouth"), which refers to knowing or understanding with a clear mind. The character for "wisdom" (智) is comprised of two components: 知 ("knowledge") and 日 (radical for "sun"). In the words of Confucius: "When you know a thing, to hold that you know it, and when you do not know a thing, to allow that you do not know it—this is knowledge."

Light

guāng

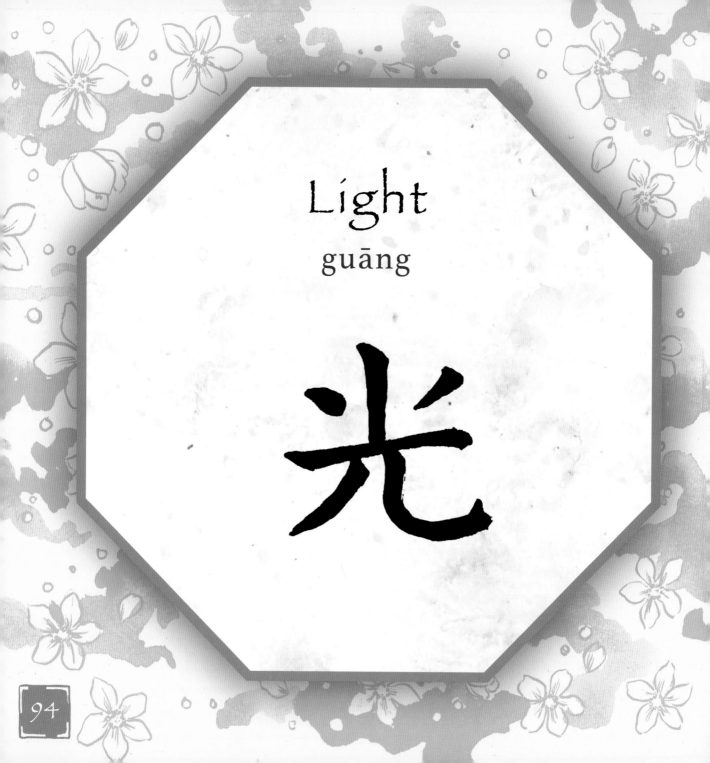

光 • Light

In oracle shell writing, the character for "light" is a combination of 火 (radical for "fire") on top of 儿 (radical for "person"). The character depicts someone holding up a torch, which provides a light that would shine through darkness. When combined with the character 明 ("clear"), the phrase 光明 (*guāng míng*) means "bright and promising with hope." Light always gives hope and brightens the spirit.

Listening

líng

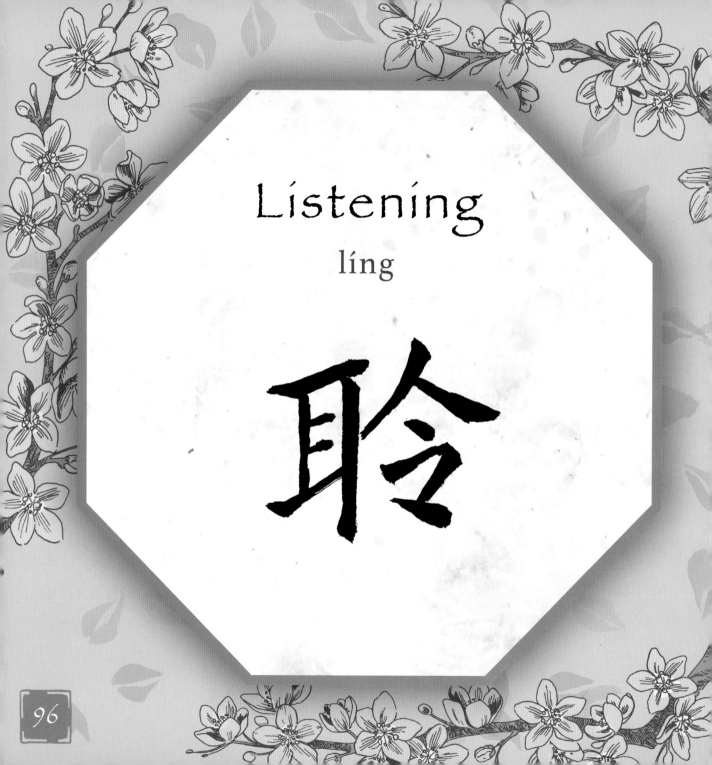

聆 • Listening

The character for "listening" consists of two parts: 耳 ("ears") and 令 ("order"). 聆 can also mean "hearing." It is usually combined with 聽 (the various parts of the character translate literally to "I give you my ears, my eyes, my undivided attention, and my heart"). The phrase 聆聽 (*líng tīng*) means "to listen attentively." In the words of a Chinese proverb: "To listen well is as powerful a means of influence as to talk well, and is essential for all conversation."

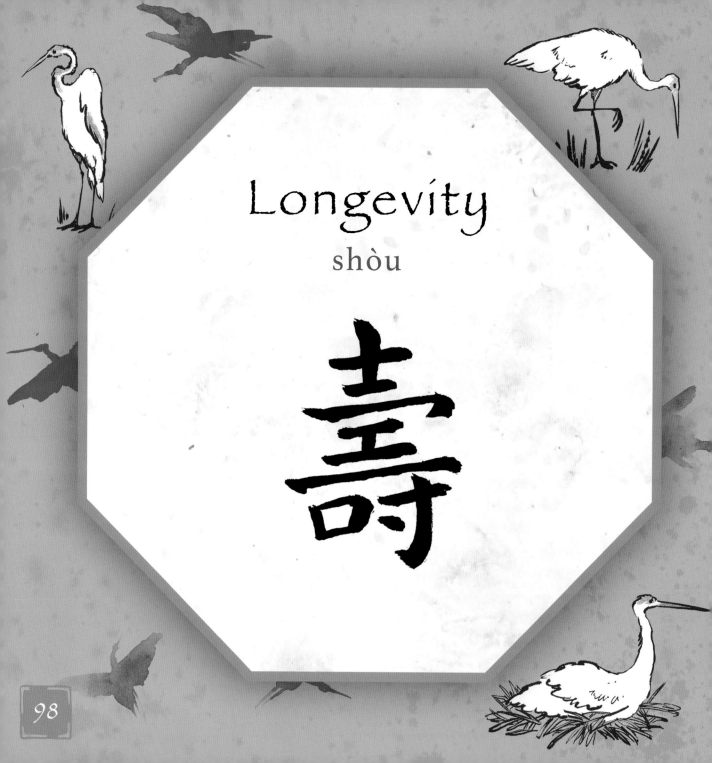

Longevity

shòu

壽

壽 • Longevity

壽 is an auspicious character representing long life. In Chinese mythology, the character for "longevity" is one of the three lucky deities: 福祿壽 (*fú lù shòu*—"happiness," "fortune," and "longevity"). The three deities are often depicted in paintings and statues. The Chinese phrase 壽比南山 (*Shòu bǐ nán shān*)—which roughly translates to "May you live as long as the mountains!"—is often used as birthday-blessing wishes for the elders.

Meditation

chán

禅

禪 • Meditation

In ancient Chinese writing, the character
for "meditation" referred to royal ritual
ceremonies such as paying homage to the spirits
or gods. In Buddhism, 禪 means sitting quietly and
still, abandoning all thoughts and entering into
deep contemplation and deliberation. "Zen" is the
Japanese translation of the Chinese word "*chán.*"
To quote Hui Neng (638–713)—a prominent
Buddhist monk—"zen" is defined as
"seeing into one's own nature."

Nine

jiǔ

九

九 • Nine

The original meaning of 九 was 肘 ("elbow"). It was later used to represent the number nine. In ancient China, odd numbers were considered *yang* ("light"), while even numbers were *yin* ("dark"). Nine is the highest *yang* number and is usually associated with the emperor. This character is one of the auspicious numbers because it is a homophone of the character 久 (*jiǔ*)—"a very long time."

One

yī

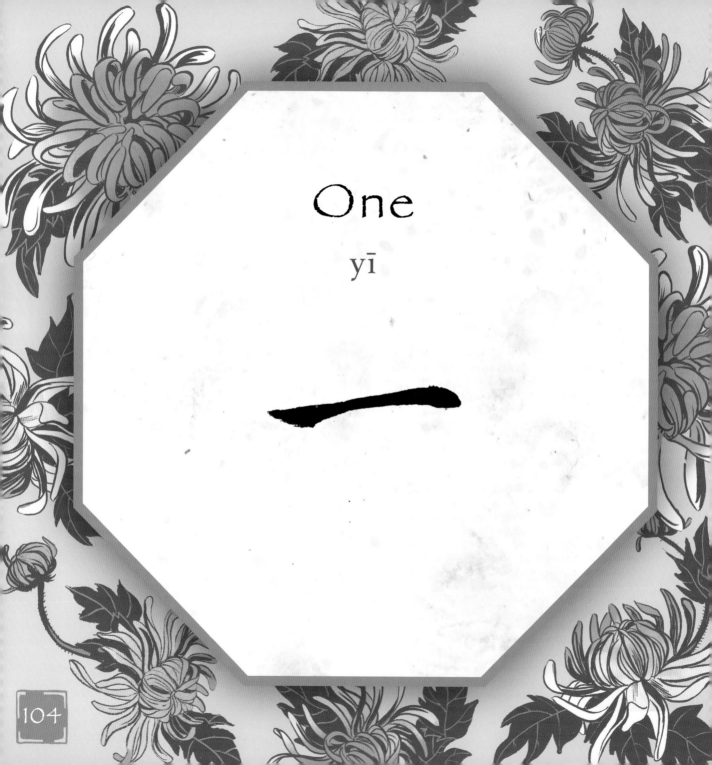

一 • One

Written with a single, straight, horizontal line, the simplest Chinese character is 一. It is the first entry in the Chinese dictionary. Besides representing the number one, or a single unit, 一 has several different meanings. The character also means "only" and "single-minded," as well as "special" and "unique." The phrase 一心一意 (*yī xīn yī yì*) means doing something single-mindedly and wholeheartedly. In Taoism, 一 conveys the "beginning" of all things.

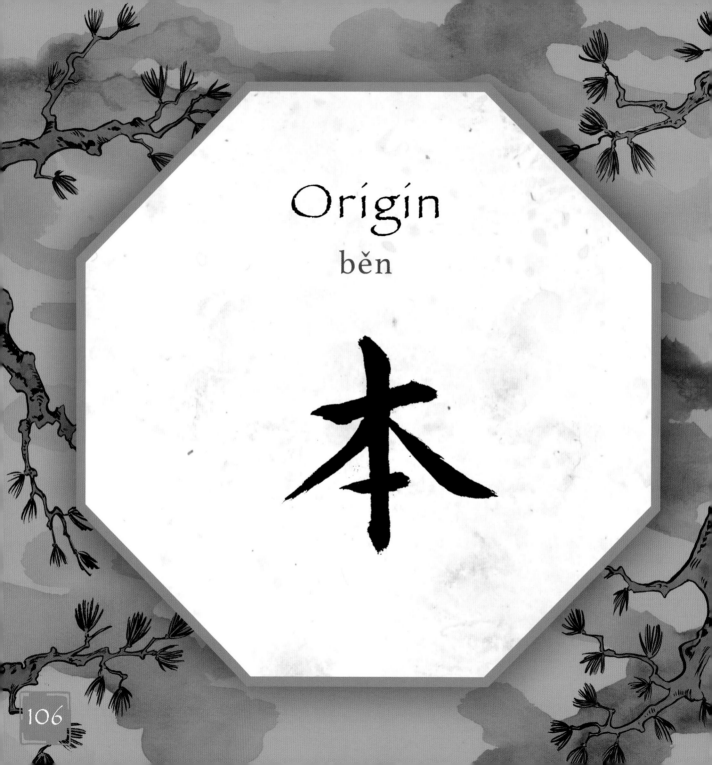

Origin

běn

本 · Origin

本 originated from the character 木 ("wood"), which looks like a tree with leaves and branches. The single line at the bottom (一) represents the root of the tree. The character usually means "basic," "origin," "root," and "foundation." 本 can also mean "oneself." As one Chinese proverb says: "When the root is firm, the branches flourish." In other words, good development depends on a solid foundation.

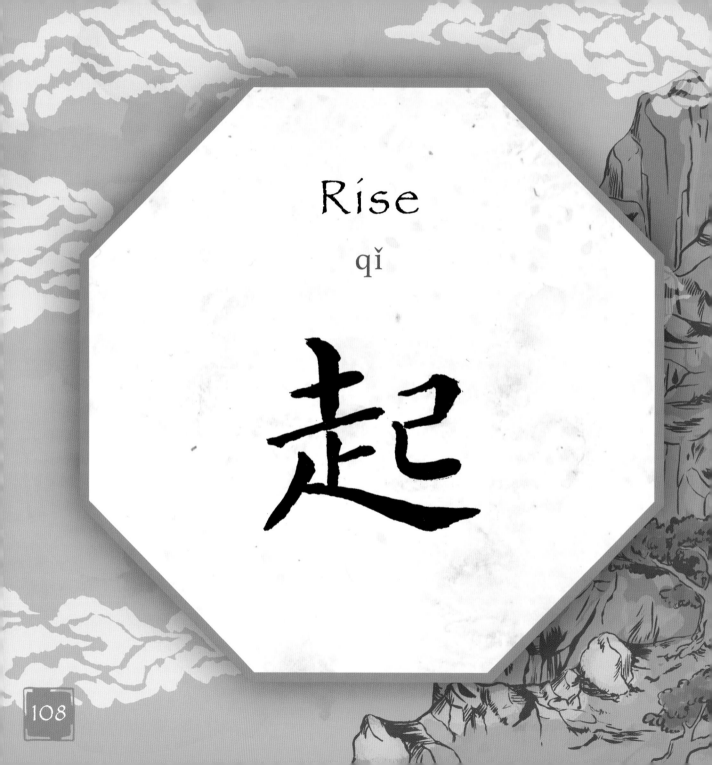

Rise

qǐ

起

起 • Rise

起 is a combination of two characters:
走 ("going") and 巳 ("begin"). 起 means
getting up and starting to walk. The character
can also mean starting something new and
rising to the occasion. The Chinese phrase
東山再起 (*Dōng shān zài qǐ*)—literally meaning
"The East Mountain will rise again"—describes
how after a person has failed, they can
become successful again. The phrase
is synonymous with the English
word "comeback."

Simple

jiǎn

簡

簡 • Simple

簡 has two components: 竹 (radical for "bamboo") and the character 間 ("section"; "between"). It originally referred to the letters that were written on bamboo planks in ancient China, which were lightweight and convenient to use. 簡 can also mean "brief." The phrase 以簡馭繁 (*yǐ jiǎn yù fán*) means using a simple, concise method to deal with complicated matters. In the words of Confucius: "Life is really simple, but we insist on making it complicated."

CHARACTER STROKES

When writing Chinese calligraphy, it is important to maintain a calm and focused mind in a quiet environment with ambient lighting. Writing should be done on a table with an even, flat surface, while seated in a comfortable chair that encourages proper posture.

TOOLS FOR TRADITIONAL CHINESE CALLIGRAPHY

Paper: Calligraphy is usually done on highly absorbent paper made of elm tree bark (40 to 80 percent) called Xuan paper. Xuan paper is available at reputable art supply stores.

Brush: Choose round brushes made with animal hair that can hold an adequate amount of ink. The most popular brushes are those made with hair from a goat, wolf, horse, or rabbit.

Ink stick: Ink sticks are made primarily of fine powdery charcoal mixed with glue.

Inkstone: Ink is produced by patiently grinding an ink stick against the inkstone with a small amount of water.

(*Note*: Black watercolor paint or india ink can substitute well for traditional ink. The makeup isn't that different, and using watercolor or india ink will remove the need for an ink stick and an inkstone.)

TOOLS FOR REGULAR WRITING

Paper: If you are not using the practice journal, which accompanies this book, you may choose any kind of paper.

Marker: Brush-tip markers (or brush pens) are good for practicing.

Pen: You may also use a ballpoint pen, but felt-tip pens of any type are better for practicing because you can see the strokes better.

Basic Strokes

To assist with your calligraphy practice, a detailed representation of the strokes for each character has been included. For ease of reference, the characters are listed alphabetically by their English translations. Before beginning, though, it is important to be familiar with the basic strokes in Chinese calligraphy.

A "stroke" is the smallest component of a character. There are many different types of strokes; they are very similar to each other but not the same. By combining these basic strokes, many different characters can be created. Below, I am including the eight most basic strokes that are essential to all beginners:

1. horizontal 「一」
2. vertical 「丨」

3. dot 「、」
4. vertical hook 「亅」
5. upward stroke toward right 「´」
6. downward stroke toward left 「丿」
7. downward stroke toward right 「乀」
8. bend 「乚」

STROKE ORDER

The four basic directions for the order of the strokes are:

1. top to bottom
2. left to right
3. horizontal before vertical stroke
4. left downward stroke before right downward stroke

Keeping the above in mind will make it easier to learn each character!

WORD (Part Section)	CHARACTER (Pinyin)	STROKES					

WORD (Part Section)	CHARACTER (Pinyin)	STROKES
Affection (Emotion)	情 (*qíng*)	丶 忄 忄 忄 忄 忄 1 2 3 4 5 6 忄 忄 情 情 情 7 8 9 10 11
Bird (Nature)	鳥 (*niǎo*)	丿 亻 仢 白 白 自 1 2 3 4 5 6 鳥 鳥 鳥 鳥 鳥 7 8 9 10 11
Blessing (Enlightenment)	福 (*fú*)	丶 冫 礻 礻 礻 礻 1 2 3 4 5 6 礻 福 福 福 福 福 7 8 9 10 11 12 福 13
Calm (Emotion)	平 (*píng*)	一 丷 丆 五 平 1 2 3 4 5

WORD (Part Section)	CHARACTER (Pinyin)	STROKES
Center (Enlightenment)	中 (*zhōng*)	丶 口 口 中 1 2 3 4
Contentment (Emotion)	滿 (*mǎn*)	丶 冫 氵 氵 汁 汁 1 2 3 4 5 6 汁 汁 洪 満 満 滿 7 8 9 10 11 12 滿 滿 13 14
Destiny (Enlightenment)	運 (*yùn*)	丶 冖 冖 尸 冒 冒 1 2 3 4 5 6 冒 宣 軍 軍 運 運 7 8 9 10 11 12 運 13

119

WORD (Part Section)	CHARACTER (Pinyin)	STROKES					
Dream (Emotion)	夢 (*mèng*)	丶 1	十 2	艹 3	艹 4	艹 5	艹 6
		艹 7	茁 8	茁 9	茁 10	蓝 11	夢 12
		夢 13	夢 14				
Empowered (Enlightenment)	能 (*néng*)	厶 1	厶 2	仒 3	育 4	育 5	育 6
		育 7	育 8	能 9	能 10		
Eternal (Enlightenment)	恆 (*héng*)	丶 1	忄 2	忄 3	忄 4	忄 5	忦 6
		忦 7	恆 8	恆 9			
Exhale (Enlightenment)	舒 (*shū*)	丿 1	人 2	仒 3	仒 4	牟 5	牟 6
		舍 7	舍 8	舒 9	舒 10	舒 11	舒 12

WORD (Part Section)	CHARACTER (Pinyin)	STROKES
Exist (Enlightenment)	存 (*cún*)	一 ナ オ 右 存 存 1 2 3 4 5 6
Feather (Nature)	羽 (*yǔ*)	丁 ヨ ヨ 羽 羽 羽 1 2 3 4 5 6
Fly (Enlightenment)	飛 (*fēi*)	て て て て 飞 飛 1 2 3 4 5 6 飛 飛 飛 7 8 9
Forgive (Emotion)	諒 (*liàng*)	、 亠 亠 言 言 言 1 2 3 4 5 6 言 訁 訪 訪 訪 諒 7 8 9 10 11 12 諒 諒 諒 13 14 15

WORD (Part Section)	CHARACTER (Pinyin)	STROKES					
Gentle (Emotion)	柔 (róu)	マ 1	マ 2	又 3	予 4	矛 5	圣 6
		柔 7	柔 8	柔 9			
Good (Emotion)	好 (hǎo)	く 1	女 2	女 3	奵 4	奵 5	好 6
Happiness (Emotion)	喜 (xǐ)	一 1	十 2	士 3	吉 4	吉 5	吉 6
		吉 7	吉 8	壴 9	壴 10	喜 11	喜 12
Heart (Emotion)	心 (xīn)	丶 1	心 2	心 3	心 4		
Home (Emotion)	家 (jiā)	丶 1	丷 2	宀 3	宀 4	宁 5	宁 6
		宇 7	家 8	家 9	家 10		

WORD (Part Section)	CHARACTER (Pinyin)	STROKES					
Hope (Emotion)	望 (*wàng*)	丶 1	二 2	亡 3	丬 4	切 5	竹 6
		切 7	竹 8	望 9	望 10	望 11	
Jade (Nature)	玉 (*yù*)	一 1	二 2	干 3	王 4	玉 5	
Journey (Enlightenment)	旅 (*lǚ*)	丶 1	二 2	亠 3	方 4	方 5	方 6
		㫃 7	旅 8	旅 9	旅 10		
Kindness (Emotion)	善 (*shàn*)	丶 1	丷 2	丷 3	丷 4	兰 5	羊 6
		羊 7	羊 8	美 9	善 10	善 11	善 12
Knowledge (Enlightenment)	知 (*zhī*)	丿 1	𠃊 2	二 3	牛 4	矢 5	知 6
		知 7	知 8				

123

WORD (Part Section)	CHARACTER (Pinyin)	STROKES					

Laughter (Emotion) — 笑 (*xiào*)

丿(1) ⺧(2) ⺦(3) ⺪(4) ⺮(5) 竹(6)
笶(7) 笁(8) 笑(9) 笑(10)

Light (Enlightenment) — 光 (*guāng*)

丨(1) 丷(2) ⺌(3) 业(4) 尐(5) 光(6)

Listening (Enlightenment) — 聆 (*líng*)

一(1) 丁(2) 丌(3) 刀(4) 耳(5) 耳(6)
耴(7) 耵(8) 聆(9) 聆(10) 聆(11)

Longevity (Enlightenment) — 壽 (*shòu*)

一(1) 十(2) 土(3) 耂(4) 吉(5) 耂(6)
壴(7) 壴(8) 壽(9) 壽(10) 壽(11) 壽(12)
壽(13) 壽(14)

WORD (Part Section)	CHARACTER (Pinyin)	STROKES					
Lotus (Nature)	蓮 (*lián*)	`	`	`	`	`	`
		1	2	3	4	5	6
		苩	苩	苩	莗	革	蓮
		7	8	9	10	11	12
		漢	蓮	蓮			
		13	14	15			
Meditation (Enlightenment)	禪 (*chán*)	`	`	衤	衤	衤	衤
		1	2	3	4	5	6
		衤	衤	衤	衤	衤	禑
		7	8	9	10	11	12
		禑	禫	禪	禪		
		13	14	15	16		
Morning (Nature)	晨 (*chén*)	`	口	日	日	旦	尸
		1	2	3	4	5	6
		尽	晨	晨	晨	晨	
		7	8	9	10	11	
Nine (Enlightenment)	九 (*jiǔ*)	ノ	九				
		1	2				

WORD (Part Section)	CHARACTER (Pinyin)	STROKES
One (Enlightenment)	一 (*yī*)	一 (1)
Open (Emotion)	開 (*kāi*)	｜(1) 尸(2) 尸(3) 尸(4) 尸(5) 門(6) 門(7) 門(8) 門(9) 門(10) 開(11) 開(12)
Orange (Nature)	橙 (*chéng*)	一(1) 十(2) 才(3) 木(4) 桴(5) 桴(6) 桴(7) 桴(8) 桴(9) 桴(10) 桴(11) 橙(12) 橙(13) 橙(14) 橙(15) 橙(16)
Origin (Enlightenment)	本 (*běn*)	一(1) 十(2) 才(3) 木(4) 本(5)
Patience (Emotion)	耐 (*nài*)	一(1) 一(2) 一(3) 而(4) 而(5) 而(6) 而(7) 耐(8) 耐(9)

WORD (Part Section)	CHARACTER (Pinyin)	STROKES					
Peace (Emotion)	和 (hé)	ノ 1	二 2	千 3	禾 4	禾 5	禾 6
		和 7	和 8				
Pearl (Nature)	珠 (zhū)	一 1	二 2	干 3	王 4	王 5	珒 6
		珜 7	玤 8	珠 9	珠 10		
Quiet (Emotion)	静 (jìng)	一 1	二 2	丰 3	主 4	青 5	青 6
		青 7	青 8	青 9	青 10	青 11	青 12
		静 13	静 14	静 15	静 16		
Rise (Enlightenment)	起 (qǐ)	一 1	十 2	土 3	牛 4	丰 5	走 6
		走 7	起 8	起 9	起 10		

WORD (Part Section)	CHARACTER (Pinyin)	STROKES					
Safe (Emotion)	泰 (*tài*)	一 1	二 2	三 3	声 4	夫 5	泰 6
		泰 7	泰 8	泰 9	泰 10		
Silk (Nature)	絲 (*sī*)	ノ 1	幺 2	幺 3	糸 4	糸 5	糸 6
		紤 7	絲 8	絲 10	絲 11	絲 11	絲 12
Simple (Enlightenment)	簡 (*jiǎn*)	ノ 1	ケ 2	竹 3	竹 4	竹 5	竹 6
		竹 7	竹 8	竹 9	竹 10	竹 11	簡 12
		簡 13	簡 14	簡 15	簡 16	簡 17	簡 18
Sunlight (Nature)	陽 (*yáng*)	ヿ 1	了 2	阝 3	阝 4	阝 5	阝 6
		阳 7	阳 8	陽 9	陽 10	陽 11	陽 12

WORD (Part Section)	CHARACTER (Pinyin)	STROKES					
Time (Nature)	時 (*shí*)	丨 1	冂 2	日 3	日 4	旷 5	旪 6
		旪 7	旪 8	時 9	時 10		
Tranquility (Emotion)	寧 (*níng*)	丶 1	八 2	宀 3	宀 4	忘 5	忘 6
		忘 7	寍 8	寍 9	寍 10	寍 11	寍 12
		寍 13	寧 14				
Waterfall (Nature)	瀑 (*pù*)	丶 1	冫 2	氵 3	氵 4	沪 5	沪 6
		沪 7	浘 8	浘 9	浘 10	湿 11	渂 12
		渂 13	瀑 14	瀑 15	瀑 16	瀑 17	瀑 18
World (Nature)	世 (*shì*)	一 1	十 2	卅 3	卅 4	世 5	

129

Acknowledgments

I am deeply grateful to the many dedicated and expert colleagues without whom this book would not have been possible.

Special thanks goes to S. M. Wu for her steadfast encouragement, tremendous editorial support, and unwavering friendship. To A.D. Puchalski, thank you for breathing life into the book with your lovely illustrations and incredibly detailed design.

Thank you, Jen Graham, for your excellent editing and keen-eyed critique. To Ching Wu, thank you for the care with which you read the manuscript and for helping steer the book in the right direction. To Ellie Bruner, your enthusiastic review and generous feedback are greatly appreciated. To Yan Wu, thank you for sharing your wisdom. Thank you, Hui Li, for your helpful advice.

To Michelle Faulkner of Wellfleet Press, thank you for believing in the book.

The Chinese-language dictionary *Xinhua Zidian,* the Chinese dictionary and encyclopedia *Cihai,* and the websites Zdic.net and ChineseEtymology.org were particularly good resources and references.

Thanks also to my family for their support, especially my brother, Joseph, who has been and remains a strong anchor in my life. Most importantly, though, I thank my daughter, Shannen, who makes me see the amazing things in life, and whose presence pushes me to better myself. This book is dedicated to her: may she cherish and be proud of her heritage.

About the Author and Calligrapher

Suvana Lin speaks fluent Mandarin and Cantonese. Born in Hong Kong, she began writing Chinese at the age of five, and studying and practicing Chinese calligraphy by the time she was twelve. Suvana moved to the United States as a teenager, and currently resides in Massachusetts with her daughter.

About the Illustrator

A.D. Puchalski is an illustrator and designer working in pen and ink, watercolor, and pixels. In addition to traditional art, she makes designer toys, which have been featured in an array of publications and galleries. For more information on A.D. Puchalski's work, please visit www.angeldevilland.com.

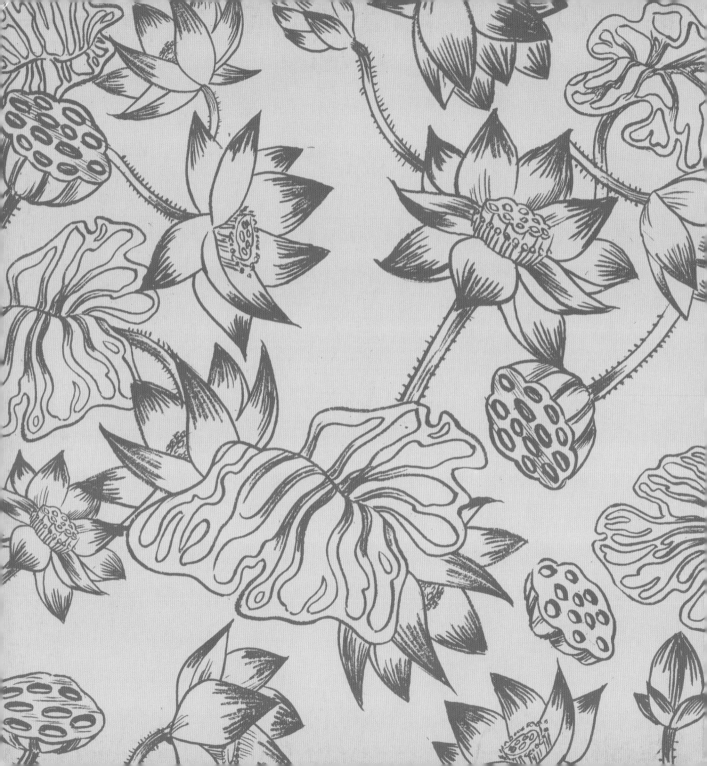